GRAFFITI LIVES, OK

Also by Nigel Rees
'Quote...Unquote'

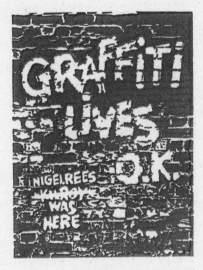

London
UNWIN PAPERBACKS
Boston Sydney

First published in Unwin Paperbacks 1979
Reprinted 1979 (five times), 1980 (once)

UNWIN ® PAPERBACKS
40 Museum Street, London WC1A 1LU

This edition © Nigel Rees 1979

ISBN 0 04 827 018 0

Typeset in 10 point Monophoto Times
by Northampton Phototypesetters Ltd
and printed in Great Britain by
Hunt Barnard Printing Ltd, Aylesbury,
Bucks.

Design David Pocknell
Cover photography Tony Evans

'A SMALL BOOK FOR THE SMALLEST ROOM'

In these pages Nigel Rees presents over 300 graffiti from parts of Britain and also from other corners of the globe. The result is as entertaining as his quiz programmes and his recently published book *'Quote . . . Unquote'*. Bawdy, brilliant, obvious, obscure, the graffiti collected here are as unpredictable as they are varied. So is their subject-matter (sexual, political, literary, metaphysical); their situation (loos, fly-overs, subways, bridges); and their sites, which range from the Bodleian Library in Oxford, via a wall in Alaska to the Ladies in Chorlton-cum-Hardy.

The moving spray can writes;
and, having writ, moves on. Nor
all thy piety nor Wit shall lure it
back to cancel half a line, nor all
thy Tears wash out a Word of it.

'Graffiti Lives, OK' was scrawled at the bottom of a newly-painted lavatory wall – a statement of defiance, if you like, against those who seek to obliterate such anonymous scribblings.

At their worst, of course, graffiti are ugly and a form of vandalism. This book seeks to celebrate the other sort – those that provide superb free entertainment.

Although some of the graffiti I have included in this collection have been around for as long as fifty years and show no sign of disappearing, there is a sense in which all graffiti are constantly in danger of being obliterated. This book aims to give them a measure of permanence.

Local authorities now organise graffiti-removing squads armed with chemical solvents, or try to steal a march on scribblers by using plastic paints upon which (it is claimed) no pen or pencil can leave a mark. This is a far cry from the eighteenth century, when the task was left to self-appointed guardians of morals like Alexander Cruden. In order to wipe out obscene and blasphemous scrawls he used to go about carrying a damp sponge.

Contemporary Crudens have discovered that the law is not necessarily on their side. The Campaign Against Racist

Slogans whose members wanted to go round Britain erasing anything they thought offensive had to be told that it was up to the owners of defaced property to decide whether they want it cleaned up.

When caught, the graffiti writer is now frequently not only punished with a fine but told to remove all traces of his handiwork. A Labour MP was not successful, however, in banning the sale of spray-paint to people under the age of 18. The urge to scribble on walls is not something that legislation can stop.

The urge is also universal. Although the majority of examples quoted in this book come from British walls there are also contributions from Australia, Canada, the United States and one or two other countries. One place where I gather you do have trouble finding graffiti is the Soviet Union. There you may face a ten-year gaol sentence for defacing property if you get caught. It is also said that nobody could bear to stay long enough in a Soviet public lavatory to write anything on the walls.

Where a place name follows an example, this merely indicates a sighting. The graffito may well occur elsewhere and almost certainly does. Incidentally, the best place to go in search of interesting graffiti in

Britain, apart from the ancient university towns, is Brighton. Don't ask me why.

For the most part I have chosen to print humorous remarks rather than political slogans or crude sexual boastings (which are primarily of benefit to the writer rather than the reader, I suppose). Despite any impression you may have gained from the cover of this book, I can say that I have never in my life painted, sprayed, pencilled or scratched any remark on any wall anywhere.

To Anons everywhere who have contributed to the public stock of harmless pleasure I say thank you.

I am also grateful to everybody who has enabled me to assemble this volume of Anon's Collected Works. Listeners to my BBC radio programme *'Quote . . . Unquote'* have been especially helpful in this respect.

Finally I must apologise for the title. **'Graffiti Lives, OK'**. I know that 'graffiti' is a plural word (it is simply the Italian for 'scratchings'), but poor grammar is as nothing compared with some of the outrageous things you will encounter in this book.

After reading it, please wash your hands.

Prepare to meet thy God.
(Evening dress optional)

bridge on the A1

The grass is always greener
on the other fellow's grave.

*Lewisham
cemetery*

Get the Abbey habit – go to
bed with a monk.

London W1

Be alert. Your country needs
lerts.

I'd give my right arm to be
ambidextrous.

*Hemel
Hempstead*

Last Tuesday's meeting of the
Apathy Society has just been
cancelled.

North London

My dad says they don't work.

*written on
contraceptive
vending machine*

I thought UDI was a contraceptive until I discovered Ian Smith.

Oxford

During the Second World War a very patriotic little character called 'Billy Brown of London Town' was devised by London Transport to exhort the public. Concerning anti-splinter netting on Tube trains 'the world's most exemplary passenger' said:
'In the train a fellow sits and pulls the window-net to bits because the view is somewhat dim, a fact which seems to worry him. As Billy cannot bear the sight, he says, "My man, that is not right! I trust you'll pardon my correction: That stuff is there for your protection."'
Underneath was commonly added, in pencil:
I thank you for your information, but I can't see the bloody station.

IF BATMAN
IS SO SMART
WHY DOES
HE WEAR
HIS
UNDERPANTS
OUTSIDE HIS
TROUSERS?

Bill Stickers Will Be Prosecuted. – Bill Stickers is innocent.

trad.

Bill Stickers is innocent, OK

Pimlico

The addition of 'OK' to slogans first became noticeable in Northern Ireland during the early 1970s, as in:

Provo Rule, OK

referring to the Provisional IRA. The 'OK' was also adopted by the Free George Davis campaign. In 1975 George Davis was given a 17-year prison sentence for taking part in a robbery and wounding with intent to avoid arrest. Those who believed in his innocence wrote the slogan

GEORGE DAVIS IS INNOCENT, OK

all over the East End of London. The campaign was taken up elsewhere and in May 1976 Davis was released from prison but not pardoned. In July 1978 he was sentenced to 15 years gaol for his part in a subsequent bank robbery.

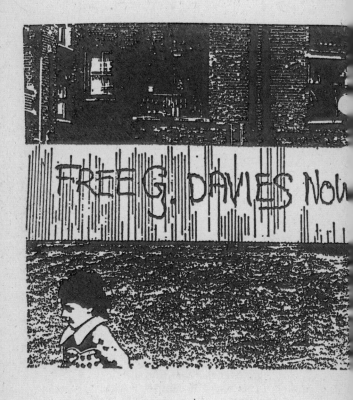

Life is just a bowl of toenails.

Oxford

God is not dead, but alive and well and working on a much less ambitious project.

Jesus wepped.

> *At the advertising agency which lost the Schweppes account.*

Do not feed the animals. They are dead.

> *Smithfield Market*

N.F.
– No Fun.
– No Freedom.
– No future.

Je suis Marxiste – tendance Groucho.

Paris, May 1968

I thought clap was a form of applause until I discovered Smirnoff.

*A*GRO.

written high up on a wall in large letters. Near the bottom in another hand:

I wish I did.

Sankey, near Warrington

*F*ree George Davis.
(to which was added:)
With every packet of cornflakes.

*S*mile! You are now on Candid Camera.

lavatory door, Stokesay Castle

*T*his is the worst chewing gum I have ever tasted.

on contraceptive vending machine

*B*uy Blitish.

> *on the wall of a*
> *Datsun*
> *distributor*

*A*ttachons nos ceintures.

> *French seat-belt*
> *slogan, to which*
> *is added:*

*E*t tirons nos braguettes.*

> *Toulouse*

*D*own with early Byzantine church music.

> *Cambridge*

*T*his wall has been designated MS Bodl. 10000 and will shortly be taken away for binding.

> *on graffiti-*
> *covered wall in*
> *the Bodleian*
> *Library, Oxford.*

*flies

*I*f the cap fits, wear it.

ladies' lavatory

*W*ritten in a cultivated hand, using fountain-pen, on railway station timetable:

Please help smash Capitalism

*C*elibacy is not an inherited characteristic.

3 *D*rink wet cement and get really stoned.

Leeds University

*D*o not pull the chain. The English need the water.

Rhayader, Wales

Christ did not say 'Kill Trees for Christmas'.

Edinburgh

It's no good looking for a joke. You've got one in your hand.

Gents, Taunton

Christine. If you're reading this, we're through.

Gents,
Bermondsey

ACID FREES THE MIND
(later modified to:)

ACID FRIES THE MIND

Harrow

A poster for the film *Young Winston* showed Churchill standing over a heap of dead Indians. Someone had drawn a speech balloon coming out of his mouth, saying:

And now for those bloody Welsh miners.

Clean air smells funny.

Clunk, click, every trip.

> *On museum*
> *chastity-belt*
> *exhibit*

Richard Coeur de Lion – first heart transplant?

> *Mold*

Does the lateral coital position mean having a bit on the side?

The grave of Karl Marx is just another Communist plot.

> *Charing Cross*
> *Road*

God is dead. Nietzsche

NIETZSCHE
IS
DEAD.
GOD

*H*arwich for the Continent
– Frinton for the incontinent.

Colchester
station

*I*n a Gents at the University of Glasgow was a vertical line of arrows pointing upwards. You followed the arrows up the wall and at the very top were a couple of lines of text in small writing. The only way to read them was to stand on the lavatory. Then you could read:

*I*t's no use standing on the seat, The crabs in here can jump ten feet.

*J*esus Saves.
– With the Woolwich.

Wandsworth

*T*he upper crust are just a lot of crumbs sticking together.

Newcastle
University

*C*unnilingus is not an Irish airline.

trad

On behalf of the Melbourne University Graffiti Writers Club we would like to welcome you. We hope you have an enjoyable and educational experience.

Keep things as they are. Vote for the Sado-Masochist Party.

Swiss Cottage

Rupert Murdoch was here and will be back with a stock. option.

Overseas Press Club, New York

You don't buy beer, you rent it.

Safeguard your health. Don't sleep with any damp women.

Einstein rules relatively, OK

AMNESIA RULES, O...

*N*ew shape! New sensitivity!

> *advert for
> condoms, to
> which has been
> added:*

*B*ut the same old feeling.

*C*olin Davis can't tell his brass from his oboe.

> *Royal Festival
> Hall*

*W*here will you be on the Day of Judgement?

> *church poster,
> South-East
> London, to which
> was added:*

*S*till here, waiting for a No. 95 bus.

*S*exual intercourse after death. Is this what is meant by getting laid in your grave?

*D*eath is nature's way of telling you to slow down.

Goodnight David

Goodnight Goliath!

*H*ave you seen the film *Deep Thought*? It's about a Girtonian whose clitoris was all in her mind.

Cambridge

*E*ven dirty old men need loving.

Gents,
Bermondsey

*T*o do is to be – Rousseau.
To be is to do – Sartre.
Dobedobedo – Sinatra.

*A*bstinence is the thin end of the pledge.

I drink therefore I am.
I'm drunk therefore I was.

Ruislip

*M*ake Love Not War.
(See driver for details.)

written in road
grime on back of
a large van

VOTE FOR DUFFY.
(And Ireland's dead will rise
up and curse you.)

> *addition to*
> *election poster,*
> *Dublin, 1925*

Six-inch Chinese dwarf wishes
to meet person with similar
interests.

> *written five feet*
> *up a wall in the*
> *Bodleian*
> *Library, Oxford.*
> *Underneath was*
> *written:*

PS This took considerable
effort.

Dwelling unit sweet dwelling
unit.

> *Notting Hill*

Don't let them cut hire
education.

> *Camberwell*
> *school,*
> *1977*

*E*ducation kills by degrees.

Bermondsey

*T*S Eliot is an anagram
of toilets.

*Leicester
University*

*C*onserve energy – make love
more slowly.

*N*ot for sale during the French
postal strike.

*contraceptive
vending machine*

*O*ne would think to read all
this wit
That Shakespeare himself
came here to shit.

trad

*W*omen like the simpler
things in life – like men.

*Ladies, Chorlton-
cum-Hardy*

I've told you for the fifty-thousandth time, stop exaggerating.

Imperial College, London

Don't throw your fag ends
in the loo,
You know it isn't right.
It makes them very soggy
And impossible to light.

trad

Modern fairy story:
And they lived happily ever
after someone else.

Birmingham

I'm a fairy. My name is Nuff.

Fairynuff.

This is not a contraceptive machine.

*written on cold
water tank,
Headingley*

*F*ar away is close at hand in images of elsewhere.

This poetic graffito (echoing 'Song of Contrariety' by Robert Graves) appeared in large letters just outside Paddington Station. 'Peter Simple', the Daily Telegraph *columnist, attributed them to 'The Master of Paddington', a genius of the brush also said to have daubed:*

WE ARE THE WRITING ON YOUR WALL

*A*n advertisement for the film *Earthquake* had the bottom stroke of the first 'E' removed and the 'H' painted out and thus read:

FART QUAKE – an earth-shattering experience.

Newton Abbot

37

*T*omorrow will be an action-replay.

*North
Kensington*

*L*ecture this evening on schizophrenia. (to which has been added:)
I've half a mind to go. (and the further comment:)
I'm in two minds also.

GOD BLESS ATHEISM.

*T*he future is female.

– Unreliable, full of broken promises, pretty to look at, but horrible to face.

Cambridge

*W*ritten at top of urinal wall:

If you can aim this far you should be in the fire brigade.

Stockport

Archduke Franz Ferdinand found alive. First World War a mistake.

To a notice saying:

NO ACCESS

is added the advice:

Use Barclaycard instead.

Birmingham

Notice on country footpath:

FREE ACCESS.

Added underneath:

Until the bull charges.

Work for the Lord. The pay is terrible but the fringe benefits are out of this world.

*lavatory at
Anglican
theological
college*

Dyslexia lures, KO

*I*l fait froid.

To which someone had added:

Clement weather?

Aberdeen

ASTIGMATIS

*Q*ueen Elizabeth rules UK

*F*ighting for peace is like
fucking for virginity.

Covent Garden

*W*ritten below the light
switch in a lavatory:

A light to lighten the genitals.

Oxford

In one train lavatory, having complied with the injunction 'Gentlemen lift the seat', you found:

Not you Momma, sit down.*

M RULES OK

written in letters five feet tall

Road sign in Lincolnshire:

TO MAVIS ENDERBY
AND OLD BOLINGBROKE.

Someone has added:

The gift of a son.

*Catchphrase from wartime radio series Hi Gang.

Back in a minute – Godot.

Dept. of English,
Columbia
University,
New York

Don't vote. The Government will get in.

Oxford

An excellent quaffer called Rafferty
Went into a Gentlemen's lafferty.
The walls caught his sight,
Quoth he: 'Newton was right.
I'm now in the centre of Grafferty!'

London N8

Alas, poor Yorlik, I knew him backwards.

Leicester

Down with gravity.

Battersea

I love grils.
(which was corrected thus:)

You mean girls, stupid!
(but then:)

What about us grils?

*H*ANDEL'S ORGAN
WORKS

(Notice in music library)

So does mine.

*T*he future of Scotland is in
your hands.

> *urinal wall,*
> *St Andrews*
> *University*

A happy Christmas to all our
readers.

> *on graffiti-strewn*
> *wall, Tenterden*

*J*oin the Hernia Society. It
needs your support.

> *Leeds University*

*F*ree the Heinz 57.

*B*EANZ MEANZ FARTZ

*D*eans means feinz.

> *New College,*
> *Oxford*

I thought Home was an ex-
Prime Minister until I
discovered squatting.

*H*OME RULE FOR WALES
– And Moby Dick for King.

*M*y mother made me a
homosexual.
(to which had been added:)
If I give her the wool, will
she make me one?

> *trad.*

*H*umpty Dumpty was pushed.

*J*oin the army, meet interesting people, and kill them.

> *Bromley*

*F*REE WALES.
– Who from? What for?

> *South
> Glamorgan*

*C*an you beat my total of 71 men – If you supply the whips.

*S*omeone somewhere wants a letter from you.

> *contraceptive
> vending machine.*

I wish I were what I was when I wished I were what I am.

> *Ladies,
> Tonbridge*

*I*s there any intelligent life on earth? – No. I'm only visiting.

Buggery is boring.
Incest is relatively boring.
Necrophilia is dead boring.

Maidenhead

God was a woman.
– Until she changed her mind.

We shall not sacrifice the blue
skies of freedom for the grey
mists of an Irish Republic.

Belfast

IVER 1.
(Road-sign, amended to:)

IVER big 1.

Support Women's Lib. Make
him sleep in the wet patch.

Advertisement at bus-stop in
Streatham Vale:
It's 85° in Jamaica right now.
What are you waiting for?

– Any bus to Brixton.

Jesus said to them, 'Who do you say that I am?' They replied, 'You are the eschatological manifestation of the ground of our being, the kerygma of which we find the ultimate meaning in our interpersonal relationships.' And Jesus said, 'What?'

*St John's
University,
New York*

Passengers are requested not to use the toilet whilst the train is standing at a station.

exept at Aldershot

trad.

Another exhortation from the 'world's most exemplary passenger', Billy Brown of London town:

Face the driver, raise your hand – You'll find that he will understand.

Someone had added:

Yes, he'll understand, the cuss, but will he stop the blasted buss?

MARCH ST. 13
IS
PROTESTANT

OM FOR THE GREY MISTS OF AN IRISH REPUBLIC

E QUEEN.

.V.F. RULE.

MCLACHLAN

Brian loves Jonathan.
– So did David. Read your
Bible.

Reigate

If God wanted to give the
world an enema he'd stick the
tube in Benidorm.

Tavistock

Kentucky Freud Chicken.
Mother-fuckin' good.

Camden

Cuts out oven doubt.

*contraceptive
vending machine*

GRAFFITI

Dr Kissinger should be bloody well hung.
– He is, he is.
(signed) Mrs Kissinger.

Bolton

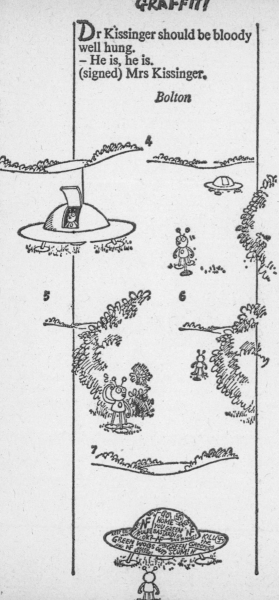

Peals of laughter
Screams of Joy
I was here before Kilroy.*

Shut your mouth. Shut your
face, Kilroy built the ruddy
place.

Gents, Tring

Sing and shout
And dance with joy
For I was here before Kilroy.

Alas, my friend, before you
spoke, Kilroy was here, but his
pencil broke.

Portmeirion

If I could choose the place
where I die it would be London
because then the transition
from life to death would hardly
be noticeable.

Hammersmith

*Numerous explanations have been
given as to how 'Kilroy was here'
originated. One is that a shipyard
overseer in Massachusetts would chalk
these words up when he had
completed an inspection. It became
common during the Second World
War wherever American servicemen
were stationed.

Is there nobody queer in Kirkudbright?

Marghanita Laski was a Bunny Girl.

London, W1

In People's China the workers take the lead. (to which was added:)
In capitalist England, the sods also take the iron, copper, floorboards and fillings from your teeth.

Euston Station

Homes before offices.
People before cars.
– Leg before wicket.

Oxford

100,000 lemmings can't be wrong.

Balliol College, Oxford.

Balliol wall is the people's organ. Contributions welcome.

Is there a life before death?

> *cemetery wall,*
> *Ballymurphy,*
> *Northern Ireland*

Northern Ireland has a problem for every solution.

Written above the gap at the bottom of a lavatory door: Beware limbo dancers!

> *trad.*

Written high up on the wall above a urinal in Chatham: What are you looking up here for? Are you ashamed of it?

Llantrisant.
– the hole with the Mint in it.

> *road-sign*

Heisenberg probably rules,
OK*

Saliva drools, OK

Tonbridge

On a Norfolk village poster
advertising a talk on 'What to
do if you are going bald',
someone had pencilled:
Prepare to meet thy dome.

You're never alone with
schizophrenia.

Service area,
M6 motorway

Make love not war.
– Amo, amas, amat it again.

Victoria Station

Werner Karl Heisenberg was the
German physicist who proposed the
uncertainty principle (1927).
(I think – Ed.)

British Airways poster:
– Breakfast in London.
– Lunch in New York.
– Luggage in Bermuda.

Give masochists a fair crack
of the whip.

Masturbation is habit-forming
(to which has been added,
in another weary hand:)
Now he tells us.

Richmond,
Surrey

God is not dead. He just
couldn't find a place to park.

Matriculation makes you deaf

Oxford

And the meek shall inherit the
earth – if that's all right with
the rest of you.

Sunderland

GRAFFITI

The best laid plans of mice
and men are filed away
somewhere.

Whitehall

Jesus saves.
– Save yourself. Jesus is tired.

Military intelligence is a
contradiction in terms.

*Ministry of
Defence building,
London (briefly)*

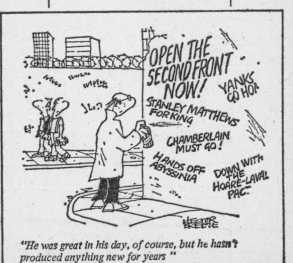

*"He was great in his day, of course, but he hasn't
produced anything new for years"*

*D*o you have trouble in making up your mind? — Well, yes and no.

Bristol

*H*ow happy is the moron
He doesn't give a damn.
I wish I were a moron,
My God, perhaps I am!

service area,
M1 motorway

*T*he British Nazi Party is a National Affront.

*B*low your mind — smoke dynamite.

*G*o Gay — it's cheaper.

contraceptive
vending machine

*F*ree Wales.
— With every five gallons.

Pontllanfraith,
Gwent

This cubicle will self-destruct
in ten seconds which will make
your mission impossible.

> *rest room,*
> *US airbase,*
> *West Germany*

Nicholas Parsons is the
neo-opiate of the people.

> *Harrow*

Mary Jones of 2, The High
Street does it. – So does her
mother.

> *South Wales*

Nostalgia is all right but not
what it used to be. – Don't
worry, it will be one day.

> *Cardiff*
> *University*

Nothing to do here.
And no one to do it to.

> *Bexhill-on-Sea*

Necrophilia lives.

O.O.A.Q.I.C.
I.8.2.Q.B.4.
I.P.

Margate

Come home, Oedipus, all is
forgiven. Mum. – Over my
dead body. Dad.

*Sussex
University*

Do thou unto others – then
split.

Forget Oxfam. Feed Twiggy.

I wouldn't be paranoid if
people didn't pick on me.

*P*araplegics, stand up for your rights.

> *Rainham*

*P*enalty for improper use £25.

> *warning on train*
> *communication*
> *cord*

– Special offer – 1p off.

*I*f I were you I'd avoid this place like the plague.

> *Eyam,*
> *Derbyshire*

*D*on't clean me. Plant something.

> *on a dirty car*

*I*f you can read this, you are straining at an angle of 45 degrees.

> *written low down*
> *on a lavatory*
> *door, Sydney*

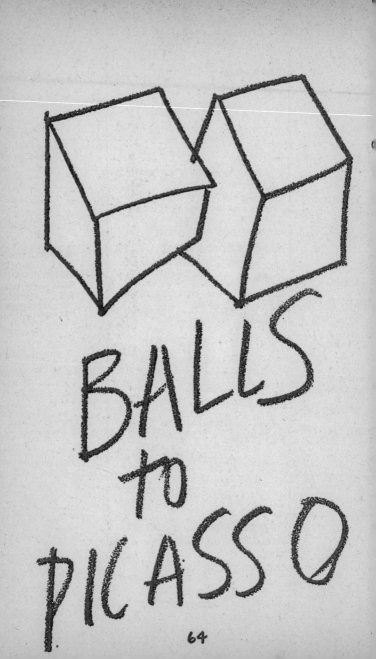

BALLS
to
PICASSO

Three-channel TV sets guaranteed working perfect, £10. – As advertised on *Police 5*

Oxford Circus

No Pope in Northern Ireland. – Lucky old Pope.

Belfast

Keep Britain tidy – kill a tourist.

Be Security Conscious. – Because 80% of people are caused by accidents.

What has posterity ever done for me?

Women's faults are many, Men have only two: Everything they say And everything they do.

Ladies, Liverpool

Predestination was doomed to failure from the start.

York
University

What will you do when God comes to Liverpool? – Switch St. John to inside left.

trad.

Princess Anne is already married to Valerie Singleton.

Ladbroke Grove,
1973

Do not adjust your mind, there is a fault in reality.

Brighton

Sudden prayers make God jump.

Save trees – eat a beaver.

Leicester

*T*his is your last chance to stay a virgin.

> *on railway*
> *communication*
> *cord*

*B*efore you meet your handsome prince you have to kiss a lot of toads.

> *Ladies,*
> *Chorlton-cum-*
> *Hardy*

*B*uy now while shops last.

> *Londonderry*

*A*nd the angel said unto the shepherds, 'Shove off. This is cattle country.'

> *Royal College of*
> *Art, London*

*S*ome girls shrink from sex. Others just get bigger ... and bigger.

> *Luton*

*P*rocrastinate now!

> *Lincoln College,*
> *Oxford*

*A*re you tired of sin and longing
for rest?
(church poster, to which the
traditional addition is:)
If not, phone Bayswater ****

*A*n advertisement for the
London Underground showed
Henry VIII buying a ticket
and saying, 'Tower Hill return,
please.' Someone added:
And a single for the wife.

*S*now White thought 7-Up was
a soft drink until she
discovered Smirnoff.

*W*all, it's a wonder you don't
crash
Under the weight of all this
trash.

*P*ope Innocent is pious, OK.

Sociology degrees, please take one.

*next to lavatory
paper dispenser,
York University*

Extramural lecture
announcement:
The Unexpected in Obstetrics.
– Mary had a little lamb.

Oedipus
was a
nervous
rex.

Soldiers who wish to be a hero
Are practically zero.
But those who wish to be
civilians –
Jesus, they run into millions!

GI trad.

Don't spray it, say it.

*sprayed on a wall
in London NW1*

PERFORATION IS A RIP OFF.

Knaresborough

I thought, until I discovered Professor ******

Cambridge

I thought Smirnoff was a tank commander until I discovered Zhukov.

*S*ynonyms govern, all right.

*R*oget's Thesaurus dominates, regulates, rules, OK, all right, adequately.

Hull University

I like sadism, necrophilia and bestiality. Am I flogging a dead horse?

*S*panish punks rule, olé!

*S*tick up for your Dad. He stuck up for you.

There is no good, there is no bad, there is only truth.
– Have you looked out of the window lately?

New York

Did you make New York dirty today? – No, New York made me dirty.

Jesus was a foreigner too.

reminder to opponents of migrant workers Switzerland

Stockhausen is terrible, especially when you tread in it.

Brighton

Press this button for fifty-second speech from Mr Callaghan.

automatic hand-dryer, Keele

Road safety notice outside school:
Drive carefully. Don't kill a child. – Wait for teacher.

Texans are living proof that Indians screwed buffaloes.

Fairbanks,
Alaska

This continual redecoration is a suppression of free speech.

British Museum

Keep this bus tidy. Please throw your tickets out of the window.

Tolkien is Hobbit-forming.

Balliol College,
Oxford

Kick out the Tories.
– And look what happens.

Bristol

GRAFFITI

*O*wing to lack of interest tomorrow has been cancelled.

University of Wisconsin

I was a professional journalist until I discovered the *Tonight* programme.

BBC TV studios, 1975.

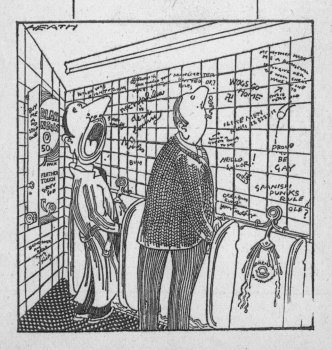

*J*esus Saves.
– but Bremner scores on the rebound.

> *trad., with different footballers' names inserted*

*J*esus Saves.
– Today he's the only one who can afford to.

> *Chatham*

*T*utankhamun has changed his mind and wants to be buried at sea.

78

VD can be cured if treated early.
– So can kippers.

*Y*ou can do it in an MG.
– Don't boast about your Triumphs.

*G*ravity is a myth. The earth sucks.

Swansea

*W*hen God made man she was only testing.

London W11

79

A woman without a man is like a fish without a bicycle.

penned as a Women's Lib. slogan, this was met by the male response:

Yes, but who needs a stationary haddock?

Psychology is producing habits out of a rat.

Racial prejudice is a pigment of the imagination.

Southampton

Place 50p in slot, wait for coin to drop, pull handle out, push back firmly

contraceptive vending machine instructions, which elicited the comment:

If this is sex it sounds extremely boring.

IF USED ON THE PREMISES SUBJECT TO V.A.T.

contraceptive
vending machine

*R*ally, Hyde Park, Sunday.

Signed,
Queen Elizabeth.

*L*YSDEXIA

Boston, Mass.

*M*arijuana is the thinking
man's cigarette.

Chase Burnett,
British
Columbia

Cowardice rules – if that's OK with you.

London, N3

Squat now – while stocks last.

on fence round property awaiting demolition, North Kensington

Today's pigs are tomorrow's bacon.

Police station

I think Elsie reads *Reader's Digest.* – I do believe she writes it.

London WC1

THROW WELL
THROW SHELL

Belfast

GRAFFITI

Reality is an illusion produced
by alcoholic deficiency.

Newcastle

Rugby is a game played by
gentlemen with odd-shaped
balls.

York University

I really don't like these places
at all,
The seat is too high and the
hole is too small.

(Underneath someone else had
written:)

To which I must add the
obvious retort:
Your backside's too big and
your legs are too short.

trad.

Religion is man's attempt to
communicate with the weather.

*Kingsbridge,
Devon*

WHY IS MAN ON
THIS PLANET?
WHY IS SPACE
INFINTE?
WHY ARE WE DOOMED?
WHY ARE YOU READING TH

ROSES ARE RED
VIOLETS ARE BLUE
YOU'RE BLOODY NOSEY
IF YOU READ THIS
ALL THROUGH

ODY SLOGAN

pon

85

Do as you are told – then revolt.

Hammersmith

Romans Go Home.

Maiden Castle

Buy me and stop one.

contraceptive vending machine, Tunbridge Wells. Alternatively:

Buy two and be one jump ahead.

Crewe Station

Queensberry Rules, KO

SLIDE RULES, OK

Roses are reddish
Violets are bluish.
If it wasn't for Jesus
We'd all be Jewish.

Amsterdam

Nixon is a Cox-sacker.

Washington,
1973

Since writing on lavatory walls
is done neither for personal
acclaim nor financial reward it
must be the purest form of art.
Discuss.

Kingston

Jesus Saves.
– Moses invests.
– Onan spends.

trad.

Two people in every one who
works for the BBC is
schizophrenic.

London WIA IAA

Radio 4 over-fortifies the over-forties.

Oedipus. Call your mother.

Heathrow

I used to think that nightingales sang in tune until I discovered Stravinsky.

Royal Academy of Music

Sex can stunt your growth.

Now he tells me!

On an Elliott's advertisement in the Tube showing two young models wearing thigh-high woollen boots someone had written:

This insults and degrades sheep.

Reality is for people who can't cope with drugs.

The Romans came to Shrewsbury in 53 AD and bugger all has happened since.

GI graffito, 1940s

Stamp out graffiti now.

Shooters Hill.

Contraceptive vending machines have been known to carry the words 'Made in the UK' or 'Approved to British Standard BS 3704' or 'Absolutely safe and reliable', to all of which the traditional response has always been:

So was the Titanic.

THE KING OF SIAM RULES BANGK, OK

—

ROONER SPULES

OK

Veni
Vidi
Vivi

Gents, Bexley

Virginity is oppression.
Liberation now.

*Leicester
University*

The wages of sin is death and
the wages at **************
are even worse. .

trad.

We are normal and we dig
Bert Weedon.

Leeds University

Samson was a strong man,
He could break an iron hoop.
But he never could have done
the feat
If he'd lived on prison soup.

Wakefield gaol

*T*ry Yoga.
– It's made out of real milk.

*F*rench dockers rule au quai.

> *Wolverhampton
> station*

*T*here was no way. Zen there
was.

> *London N8*

*I*s the Regen*'*s Park Toilet a
Zulu?

*V*idi.
Vici.
Veni.

*H*ypochondria is the one
disease I haven't got.

*W*ET PAINT.
– This is not an instruction.

*L*egalise telepathy.
– I knew you were going to
say that.

*T*here are Pharoahs at the
bottom of our garden.

Cairo hotel

I thought Wanking was a town
in China until I discovered
Smirnoff.

Vindaloo purges the parts the other curries cannot reach.

George Gershwin rules, 'Oh, Kay!'

Sod the Jubilee – yeah!

*London,
NW1, 1977*

*R*odgers and Hammerstein
rule, Oklahoma.

London pub

I hate graffiti.
– I hate all Italian food.

Cambridge

God is·dead

OH NO IM NOT

*I*t's a lie. I was never here.

(Signed) Kilroy

*R*ita loves Malcolm.
(happy ending:)
Rita married Malcolm.

Dover

*T*his wall will shortly be
available in paperback.

Penrith

FOR YOUR OWN USE